WHAT
COLOR IS
GOODNESS?

WHAT COLOR IS GOODNESS?

A POEM BY EMILY MORRISON
ARTWORK BY PAM MCDONNELL

SUSAN SCHADT PRESS

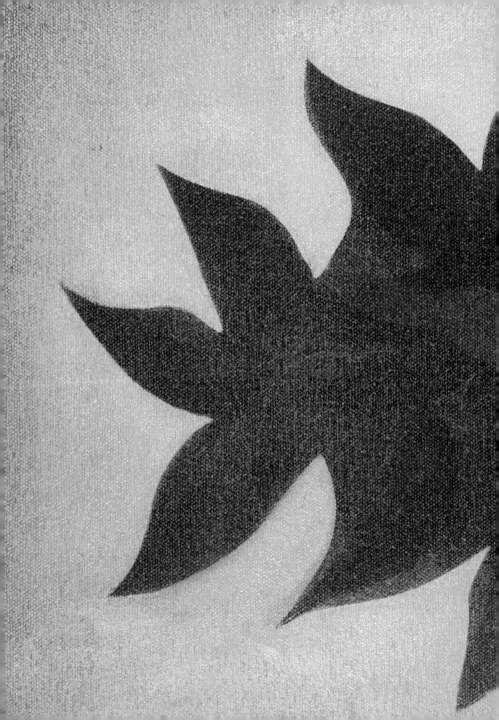

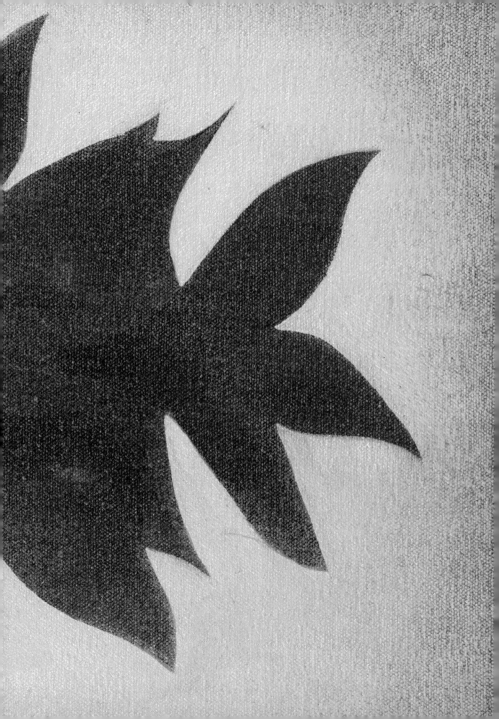

For Stirling, Logan & Rhett

PREFACE

When my six-year-old triplets were in first grade, they began a poetry unit in April to celebrate National Poetry Month. They were each tasked to memorize three poems and recite a selection in their school's poetry performance. Having raised my children on the same works that I was raised on—Shel Silverstein and A. A. Milne—I was excited for them to pick out their own favorite poems and to discover current authors. I was surprised to find very little new children's poetry. I felt compelled to write my own poems for my children, and what started as a fun exercise became a life-changing experience. The words poured out of me, and my children were enchanted and inspired by the poems. For their seventh birthdays, they begged me to read a collection of my poems to their class. The class delighted in hearing the poems and participating in the rhymes. The poems spoke to the children in the same way that I had experienced lyricism as a child.

Several months later, my cartwheeling five-year-old niece, Chilton, turned to me and asked, "Emmy, what color is goodness?" Immediately, I sensed the profound magnitude of this childhood query. Her simple curiosity had hit upon a universal question that we all needed to have answered. Written for readers of all ages, this poem explores goodness in the most unexpected places. It does not look like one color, size, or shape, and the subtleties and nuances, beauty, and undersides are always waiting to be uncovered. Goodness is found in all of us, and it is up to each of us to search for and bring about goodness and to recognize it when we see it in the world.

What color is goodness? I'm so glad that you asked!
Let's go discover. Let's unravel this path.

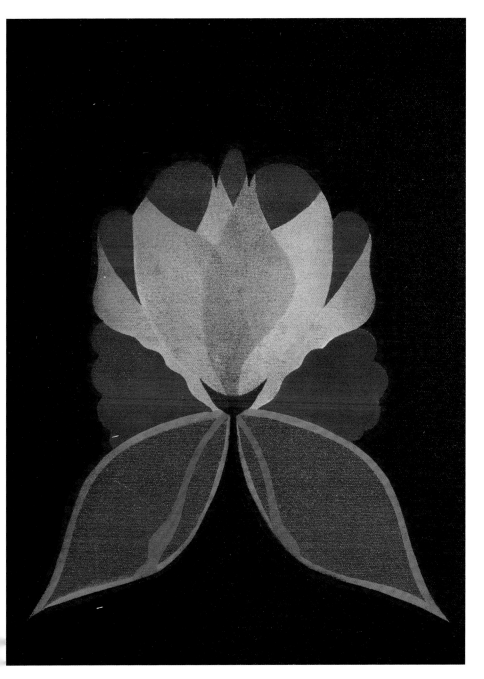

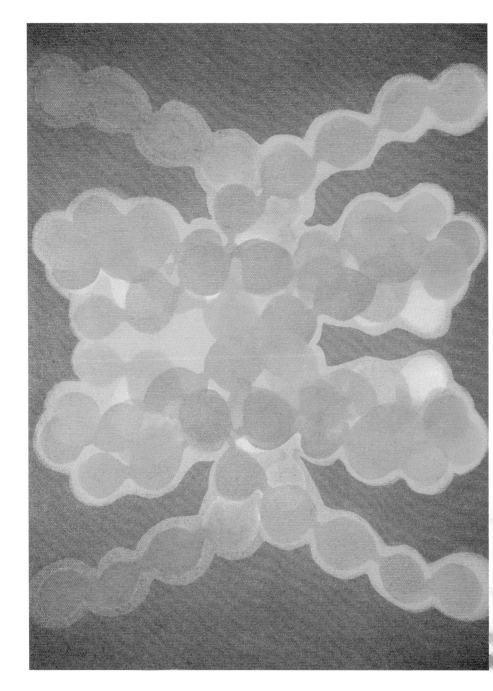

It starts off as gold or a luminous blue
Turns bubbling bright green with a purply hue.

Sometimes it's translucent, almost see-through.
Goodness is silver and slippery too.

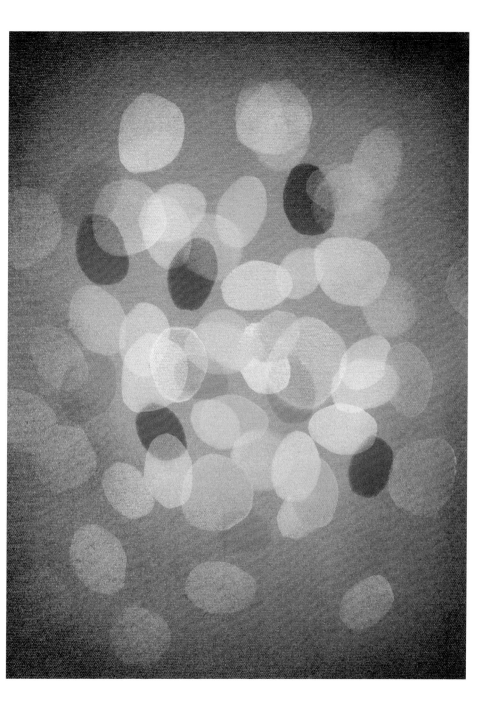

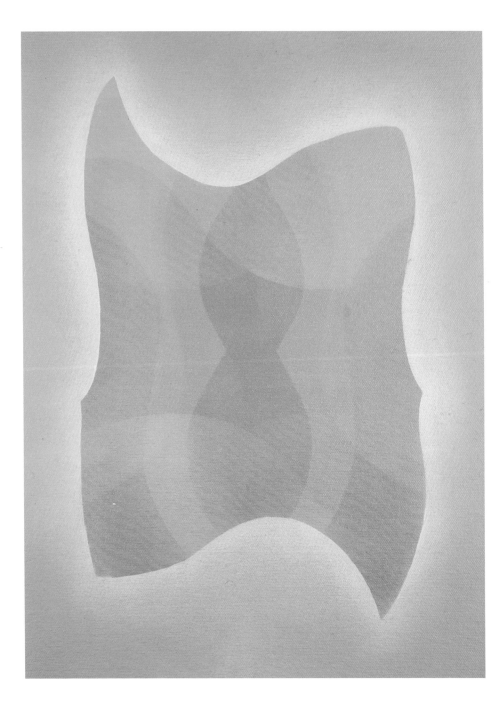

It comes in large bundles and packages small
Unexpected, beribboned, it waits there for all.

Can you order it up? Or call it at will?
Summon all of your might and stand very still . . .

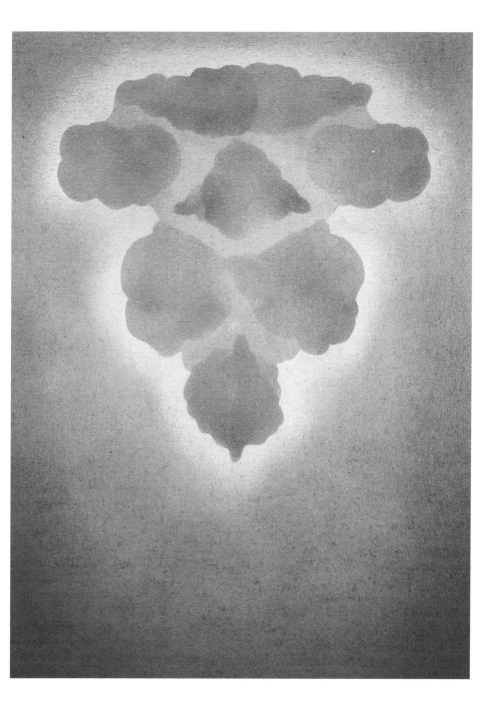

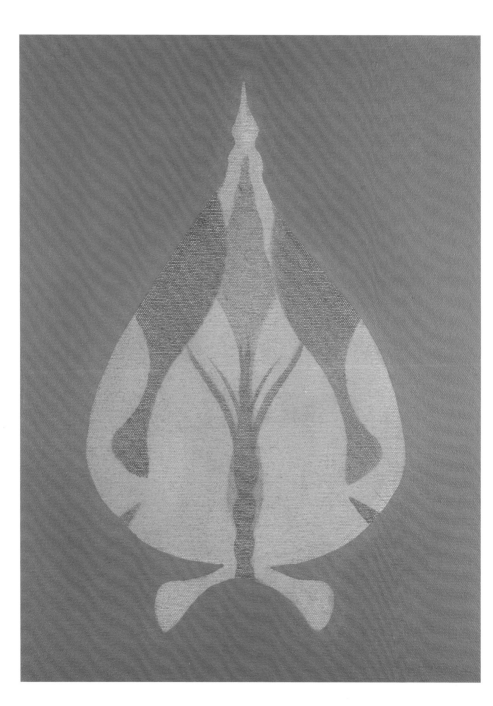

It's breathing inside, so reach deep within.
Taste the tingle of lightness as goodness sets in.

It's tender and lovely and tough all the same.
Yes, it comes when you call it!
Goodness knows its own name.

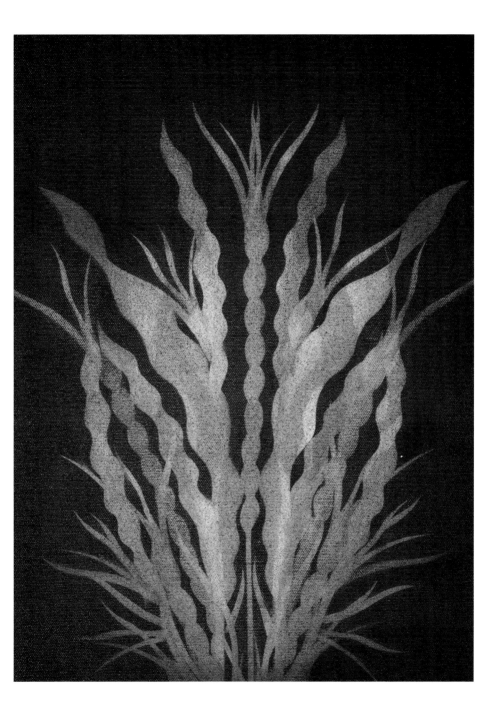

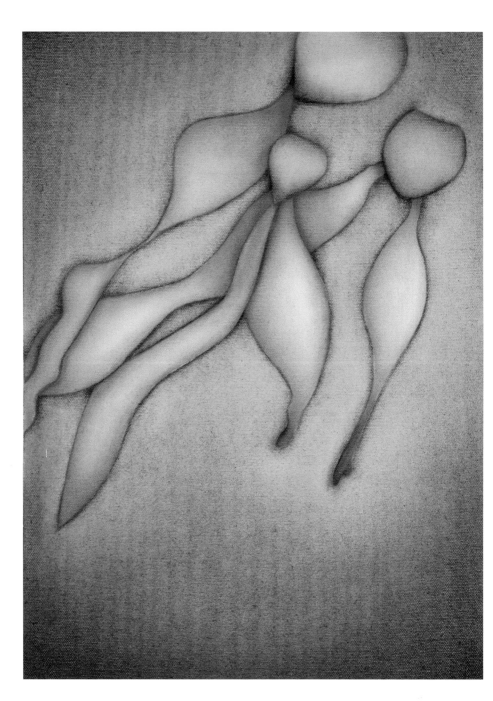

It's black and it's white. It's orange and pink.
It shimmers and sparkles and makes your heart wink.

See the grey in the midst of the dark and the light—
No more yelling or tears, no more bark, no more bite.

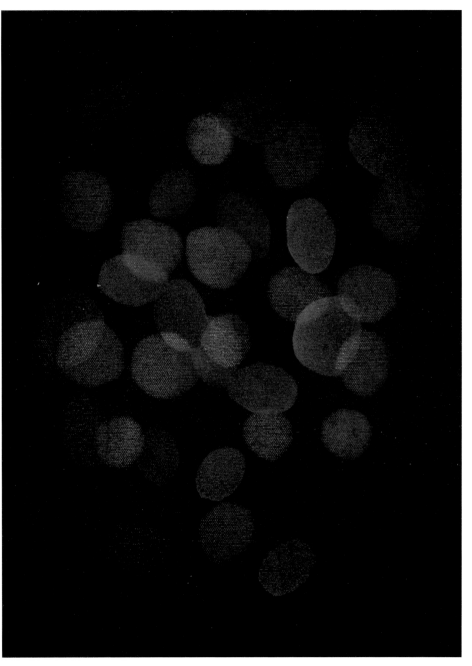

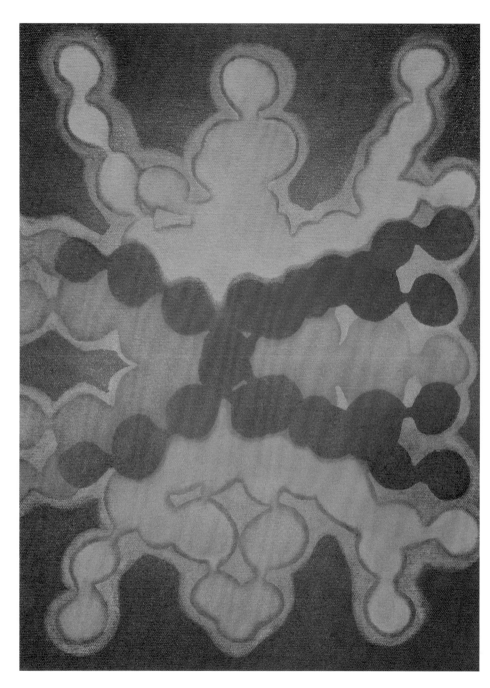

Dare to dream, share a smile, hold open the door,
sing a song, show forgiveness, and give a touch more.

Tend to your garden, watch a hummingbird fly,
squeeze the sunlight, bask in wonder,
take your soul for a ride.

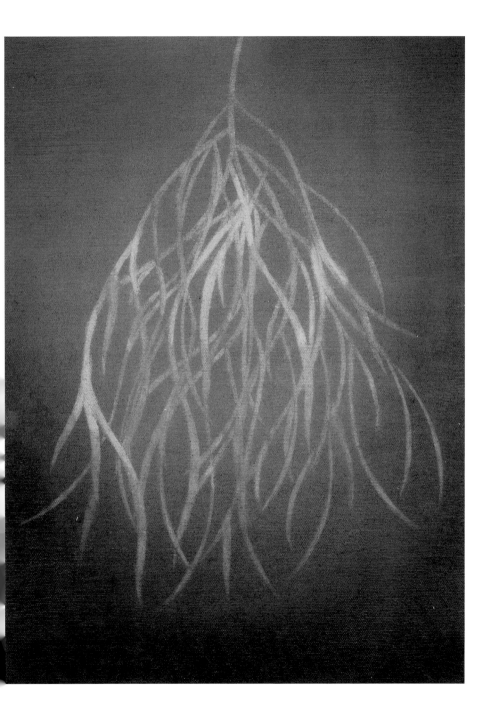

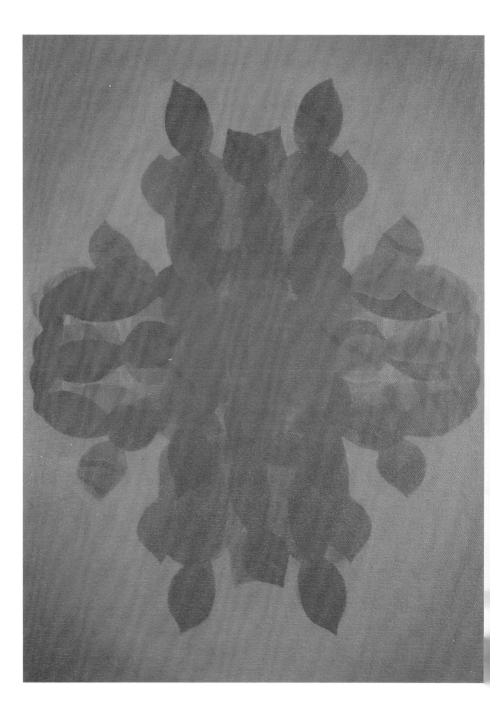

Make a splash in the puddles and hold hands as you race,
feast on laughter, harvest stillness,
gild the lines on your face.

Dance wildly, act gently, fill your life full of play,
reach out to a friend and delight in the day!

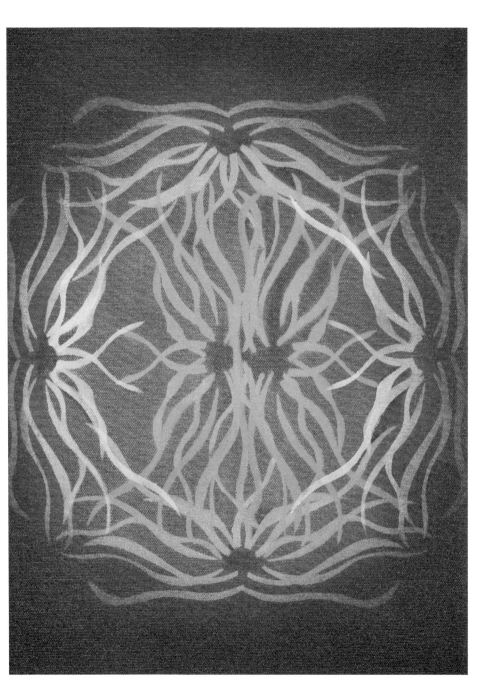

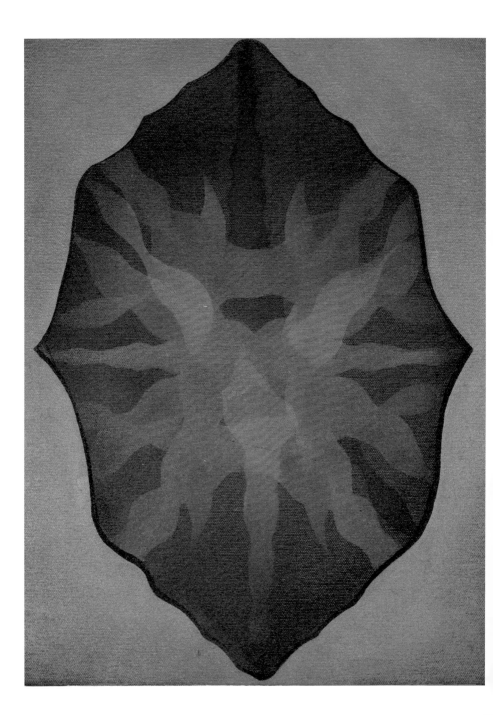

While it's there for the world, some still seem resistant.
It patiently waits—it's very persistent.

As colors unfold, your heart holds its *own* clue.

Goodness

transcends what you see—it's in what you do.

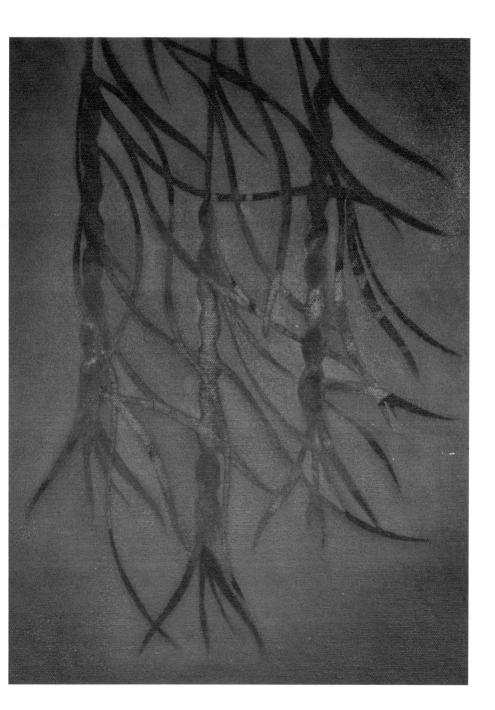

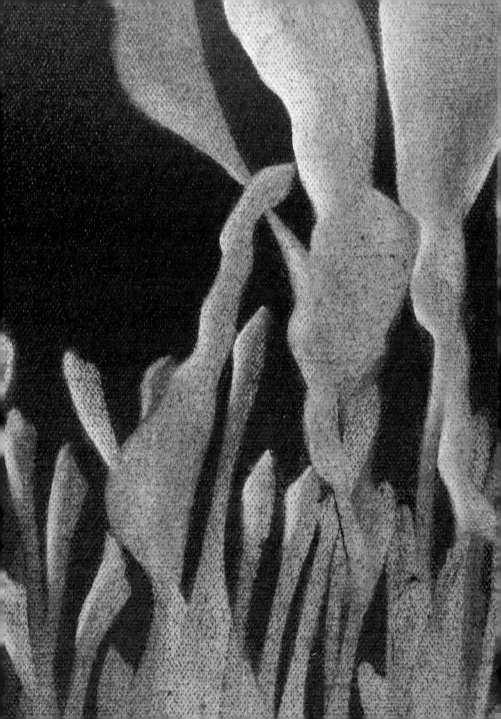

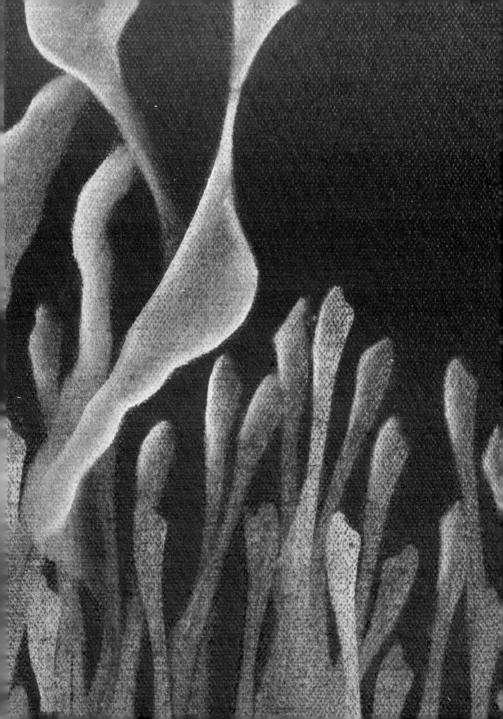

WHAT COLOR IS GOODNESS?
A POEM BY EMILY MORRISON

What color is goodness? I'm so glad that you asked!
Let's go discover. Let's unravel this path.

It starts off as gold or a luminous blue
Turns bubbling bright green with a purply hue.

Sometimes it's translucent, almost see-through.
Goodness is silver and slippery too.

It comes in large bundles and packages small
Unexpected, beribboned, it waits there for all.

Can you order it up? Or call it at will?
Summon all of your might and stand very still . . .

It's breathing inside, so reach deep within.
Taste the tingle of lightness as goodness sets in.

It's tender and lovely and tough all the same.
Yes, it comes when you call it!
Goodness knows its own name.

It's black and it's white. It's orange and pink.
It shimmers and sparkles and makes your heart wink.

See the grey in the midst of the dark and the light—
No more yelling or tears, no more bark, no more bite.

Dare to dream, share a smile, hold open the door,
sing a song, show forgiveness, and give a touch more.

Tend to your garden, watch a hummingbird fly,
squeeze the sunlight, bask in wonder,
take your soul for a ride.

Make a splash in the puddles and hold hands as you race,
feast on laughter, harvest stillness,
gild the lines on your face.

Dance wildly, act gently, fill your life full of play,
reach out to a friend and delight in the day!

While it's there for the world, some still seem resistant.
It patiently waits—it's very persistent.

As colors unfold, your heart holds its *own* clue.
Goodness
transcends what you see—it's in what you do.

ABOUT THE ARTIST

PAM McDONNELL was born in Atlanta, Georgia, in 1969 and has resided in Memphis, Tennessee, since 1996. Her alma mater is the University of Memphis, where she completed her BFA in 2005 and is currently an MFA painting candidate set to finish her studies in the spring of 2023. She combines expressive graphite drawings with thinly layered oil glazes to create work that speaks the language of spirit and connection. McDonnell has been exhibiting her work in the Memphis area since 2014 and has pieces in the public collections of West Cancer Center, Le Bonheur Children's Hospital, Church Health, and Iberia Bank. Additionally, she has volunteered her time to serve on the board of ArtsMemphis and has also served in various capacities on committees within the community to support and further the arts in Memphis.

ABOUT THE AUTHOR

EMILY MORRISON spent her childhood immersed in reading, feeling most at home in the world of poetry. After graduating from the University of Virginia with a degree in English and completing her law and business degrees at Tulane University, she detoured with a sixteen-year career on Wall Street. More recently, Morrison founded Elysian, an artisanal lifestyle brand selling handmade pieces from Istanbul, Turkey, as featured in *Forbes*, the *New York Times Style Magazine*, *Town & Country*, *Veranda*, and *Harper's Bazaar*. Her imagination cultivated, she wrote lyrical poetry to inspire emotions that can create change. She looks forward to the publication of her children's poetry anthology in the spring of 2023. A native South Carolinian, Morrison lived in New Orleans for over twenty years and recently moved to Sullivan's Island, South Carolina, with her husband, Stirling; ten-year-old triplets, Stirling, Logan, and Rhett; and their dog, Biscuit.

SUSAN SCHADT PRESS

www.susanschadtpress.com

Published in 2022 by Susan Schadt Press, L.L.C.
New Orleans

Design by Doug Turshen | Steve Turner

Library of Congress Control Number: 2022913803
ISBN: 979-8-98507-133-7
Printed by Friesens in Altona, Canada